Praise for
Prayer for the Morning Headlines

"Dan Berrigan is a national treasure, and he has added another powerful, poignant book to his towering life's work. In *Prayer for the Morning Headlines*, Father Dan offers us trenchant and timely reflections, as the subtitle says, 'On the Sanctity of Life and Death.' Adrianna Amari's photographs offer searching complements to Berrigan's poems. This work is full with the horror and hope that confront us now. Read and reflect on this book, and share it with others."

> **—Amy Goodman**
> *Democracy Now!*
> Co-Author, *Static!*

"Beautiful. Haunting."

> **—Martin Sheen**
> Activist and Actor, *The Departed* and *The West Wing*

"The steadfastness of this Saint, Daniel Berrigan, is ever revealed in his poems, again and again, as in his acts which are in perfect harmony. He tells us we must love each other and die, but as we live, we shall act in love to purge fear, hatred and violence from our being and the monstrous killers we create—nuclear bombs, war, hunger, sickness—so that others may live and love. His poetry is joined in this beautiful volume by the muses of history and art. We may ask when will these three meet again, in thunder, lightning, or in rain."

> **—Ramsey Clark**
> Former U.S. Attorney General
> Activist and Author, *The Fire This Time: U.S. War Crimes in the Gulf*

"These images—from America's greatest prophet-poet and from the acute eye of a gifted photographer—breathe and pulse. Death, too, can be a source of hope, simply in the way it bows before life. Daniel Berrigan's words and Adrianna Amari's pictures are the record of that miracle."

> **—James Carroll**
> Columnist, *Boston Globe* and Author, *House of War*

"For years, Daniel Berrigan has been offering an alternative to the bad news morning headlines with the good news of his life and poetry. He looks the culture of death in the eye and names its deadly games of war and destruction as sin and idolatry. And he offers more—the good news of resurrection. It's there between every line, in every verse, in every act of nonviolent resistance for peace and justice. Here with Adrianna Amari's photos, we feel 'the long reach and stride of love' and find hope and take heart once more."

—**Rev. John Dear, S.J.**
Editor, *And the Risen Bread: The Selected Poems of Daniel Berrigan, 1957-1997*
Author, *Living Peace* and *Jesus the Rebel: Bearer of God's Peace and Justice*

"Berrigan and Amari's *Prayer for the Morning Headlines* is deeply moving, and oddly comforting. Words and photos interplay, meditating upon death, but somehow speaking loudly, gloriously of life."

—**Stephen Duncombe**
Associate Professor, Gallatin School, New York University
Author, *Dream: Re-Imagining Progressive Politics in an Age of Fantasy*
Editor, *Cultural Resistance Reader*

"Savoring the lyrics of Father Berrigan accompanied by Amari's photographs, I am reminded of a truth delivered to me by Saint Teresa of Avila: patience achieves everything."

—**Rafael Alvarez**
Author, *A People's History of the Archdiocese of Baltimore*

Prayer for the Morning Headlines

Prayer for the Morning Headlines

On the Sanctity of Life and Death

Poems by Daniel Berrigan
Selections and Photographs by Adrianna Amari

Introduction by Howard Zinn

Baltimore, Maryland

Library of Congress Cataloging-in-Publication Data

Berrigan, Daniel.
 Prayer for the morning headlines / poems by Daniel Berrigan ; selections and photographs by
Adrianna Amari ; introduction by Howard Zinn. -- 1st ed.
 p. cm.
 ISBN 978-1-934074-16-9
 1. Anti-war poetry, American. I. Amari, Adrianna, 1965- II. Title.

 PS3503.E734P69 2007
 811'.54--dc22

 2007060771

Every effort was made to ensure the accuracy of information included in this book.

Cover photographs by Adrianna Amari
Back cover poem by Daniel Berrigan
Cover and book design by Amanda Merson

 Apprentice House
Baltimore, Maryland
ApprenticeHouse.com

c/o Communication Department
Loyola College in Maryland
4501 N. Charles Street
Baltimore, MD 21210

To all the dead,
and to all
who mourn—
we are listening

Contents

War is in the Headlines

By Howard Zinn

How can one match, in prose, the beauty of the poems and photographs in this book? I don't dare try.

All I can do is to give something of the context for Daniel Berrigan's poems and Adrianna Amari's photos. That context is the world in which we live today: a world of war and anguish, but also of hope, anticipation, the love of humanity.

The war is in the headlines, which announce every day the deaths of innocents. I count all of the dead as innocent, soldiers as well as civilians, because all are trapped in a poisonous swamp they did not know they were entering. All of them —soldiers, civilians, American, Iraqis—were thrust into danger by forces beyond their control, by mendacious governments and dogmatic sects. Religion, which should be an opiate to relieve pain and give hope (Marx, the atheist, recognized its value) has been used by fanatics on all sides —Christian and Muslim fundamentalists both— to drive people to violence, to violate the ethical principles professed by all faiths. The religious symbols in these poems and photographs do more than give comfort—they inspire.

In the poems, the war is not an abstraction. Its effects are immediate, visible, its victims are human beings we can see: "an old wife stricken…a mother nursing her sick child…that girl…dead in Paris, buried in Pere Lachaise cemetery…women and children homeless in foul weather…." The

sculptured figures in the photographs, which were chosen to match the poems, seem to be listening. They existed long before these poems were created, long before this particular war, indeed they stood silent through many wars, as if to say: "We will still be here when wars are done with. We can wait."

I came to know Daniel Berrigan—the poet, the priest—in the midst of an earlier war (there have been so many!). It was early 1968, and never having met before, we found ourselves traveling half the world from New York to Copenhagen to Frankfurt to Teheran to Calcutta—to Bangkok to Vientiane, in Laos. Why? Because although it was the time of the Tet offensive in Vietnam against the U.S. military, it was also the Tet holiday for Vietnam, and the government in Hanoi (yes, the "enemy") was going to release three prisoners, three U.S. pilots who had been bombing their country, into the custody of two members of the American peace movement. Someone in "the movement" decided that it was appropriate that the two should be a priest and a former Air Force bombardier.

We spent a week together in Vientiane, on the banks of the Mekong River, and then rode an ancient plane through the night to Hanoi. There we saw a people at war, a people bombed daily, sometimes hourly. And every morning, waking up in that dilapidated, elegant hotel, a relic of the French empire, Dan Berrigan showed me the

poem he had written the night before.

When I read his poems now, I am brought back to his steadfast, lifelong concern—the children, victims of war, looking to all of us for deliverance. One day, as the sirens sounded in Hanoi we saw a tiny child, carrying an even tinier child, into an air raid shelter. The next morning, Dan showed me his poem: "Children in the Shelter."

Here is part of it:

I picked up the littlest
a boy, his face
breaded with rice (his sister calmly feeding him
as we climbed down)

In my arms fathered
in a moment's grace, the messiah
of all my tears. I bore, reborn

a Hiroshima child from hell.

Back from the war, Father Daniel Berrigan could not remain silent as our government was bombing peasant villages in a tiny country on the other side of the world. His mode of protest was civil disobedience, made honorable by Thoreau, Gandhi, Martin Luther King, Jr., honored by Tolstoy and e.e. cummings and generations of poets, artists, resisters of all kinds, in all countries. He became one of the "Catonsville Nine" who burned draft records to dramatize their opposition to the war in Vietnam. He had written "Our apologies, good friends, for the fracture of good order, the burning of paper instead of children..."

I find it interesting that Adrianna Amari, whose photographs grace this book, met Dan Berrigan during a peace vigil on Block Island, where thirty years before he had been apprehended by the F.B.I. after months underground, refusing to accept punishment for opposing the violence of war.

From the Catonsville action to others in the decades to come, he was joining his brother Philip Berrigan, also a priest, both of them part of a small band of pacifists—Christian, Jewish, lay people—who again and again were sentenced to prison because they refused to obey the laws that forbade interfering in the slightest with the machinery of war. When the war in Vietnam ended (and who can possibly guess what part was played by these actions, and the disobedience of soldiers, and the cries of an entire nation, in finally bringing the troops back from Vietnam?) they did not stop.

The spirit of Philip Berrigan pervades these poems, as does the love between Daniel and Philip—a love born not just of their common parentage but also of their common struggle for justice. Together, they were part of the Catonsville Nine. And many years later they were together in the "Plowshares Eight," first of many acts of civil disobedience against the war machine, which were repeated all over the country and in other parts of the world, so that by 2003 one could count seventy-five such actions, involving 150 different individuals.

These men and women, pouring their own blood on weapons of mass destruction, took their cue from the book of Isaiah: "They shall beat their swords into plowshares and their spears into pruning hooks; one nation shall not raise the sword against another, nor shall they train for war again. Come, let us walk in the light of the Lord."

Philip Berrigan was in and out of prison, sometimes his wife Elizabeth McAlister was in prison at the same time, their children cared for by a loving community at Jonah House in Baltimore. He died of cancer in December of 2002, and at his funeral in Baltimore, after a procession through the cold, snowy streets of the working class neighborhood where he had been a parish priest, his children said:"He is still very present to us…and the work we do (all of us), today and tomorrow and for the rest of our lives, will keep our Dad close to us…"

It was in Baltimore, over a ten-year period, that Adrianna Amari took her extraordinary photographs of sculptures scattered through the city—of tombstones and church steeples, mothers and children.It is all there, as in Daniel Berrigan's poems—life and death, the prayer that comes with commitment, the hope that comes with resistance, the visions of a world where peace and justice prevail.

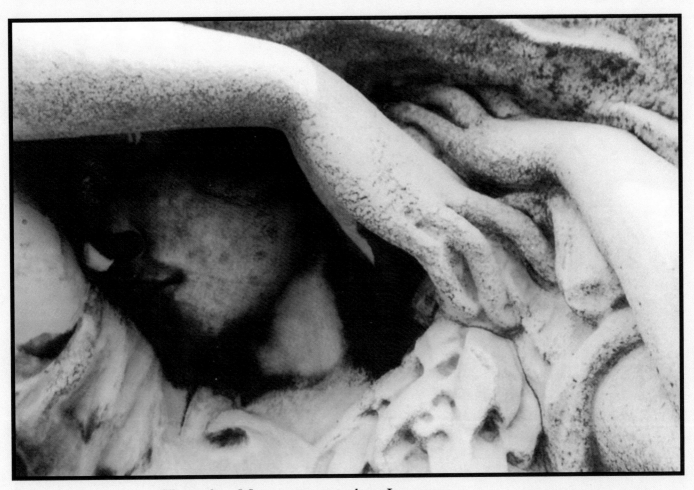

Then when Mary was come where Jesus was,
and saw him, she fell down at his feet, saying unto him,
Lord, if thou hadst been here, my brother had not died.
When Jesus therefore saw her weeping,
and the Jews also weeping which came with her,
he groaned in the spirit, and was troubled. And said,
Where have ye laid him? They said unto him,
Lord, come and see.

Jesus wept.

John 11:32-35

5

Consolation

Listen
if now and then
you hear the dead
muttering like ashes
creaking like empty
rockers on porches

filling you in filling you in

like winds in empty
branches like stars
in wintry trees
so far
so good

you've mastered finally
one foreign tongue

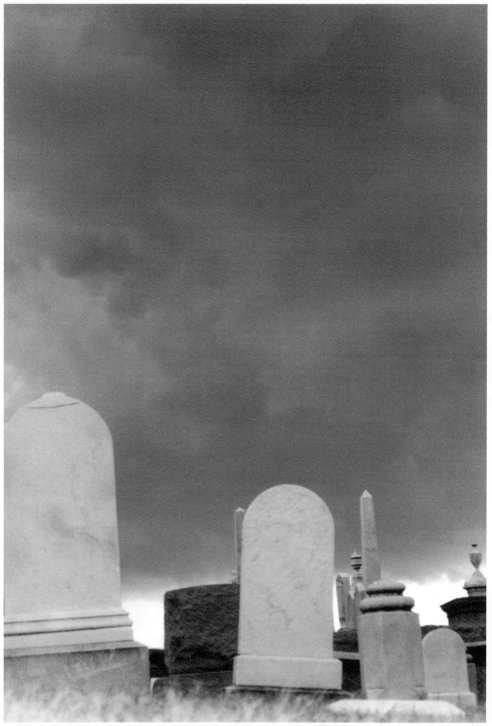

Hear Ever So Gently

Permanent beauty stands
nowhere under the tense
mainspring of time.

while I praise
color and voice of flowers
stealing my heart aside

so frail they are, this night's
starlit air has felled them.

The great cathedral takes
enemy year after year
deeper the spiritual thrust
on stained and wrinkled stone.

somewhere between its bones'
imperceptible wound
and the star-crossed flower

above a rust of bloom
under the doomed tower
hear: ever so gently

a main and springing hour

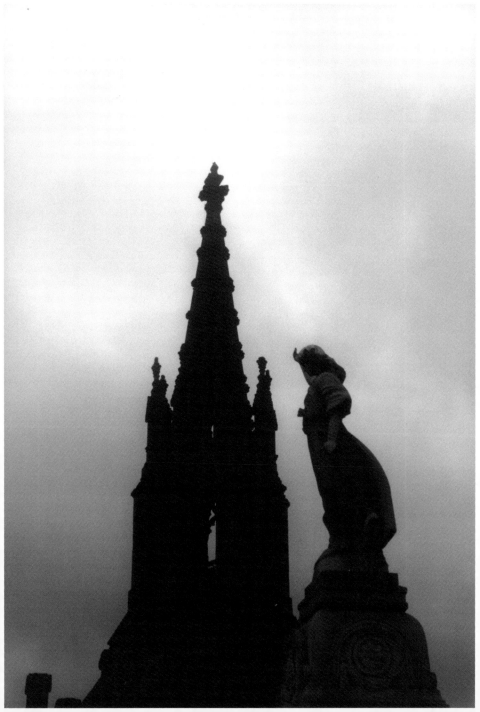

Here the Stem Rises

deflowered forever.

the bird is wise only
in ways of quiet

time is a lithe fruit
bending above us

too old for comfort
too raw for falling

here no slim morning
steps out of the sea

no season of snow
no hear-ye of thunder

no chameleon crawling
of youth or of age

not even a now
nor an I nor a you

how many the folded
hands. O how lovely

the words never spoken

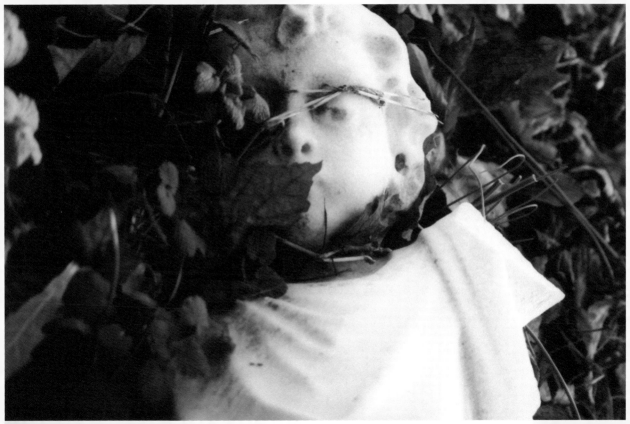

Unfinished Lines
(Paris Suite)

A bronze head of Mallarmé by Picasso—
the true burden of falling leaves.
Do humans live only in thought? Where are their hands?
Why ask? Great lines crown the brow
that crowns its quiet grove.

But how clasp hands with the dismembered dead?

No one's familiar. Listen and look long.

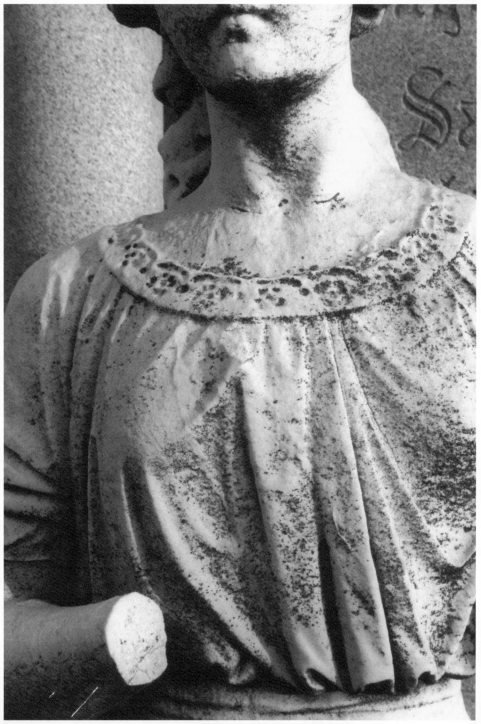

Ironies

Ironies
draw the mind free of habitual
animal ease. Sough of tides in the heart,
massive and moony, is not our sound.

But hope and despair together
bring tears to face, are a human ground,
death mask and comic, such speech
as hero and commoner devise, makes sense

contrive our face. To expunge
either, is to cast snares for the
ghost a glancing heart makes
along a ground, and airy goes its way.

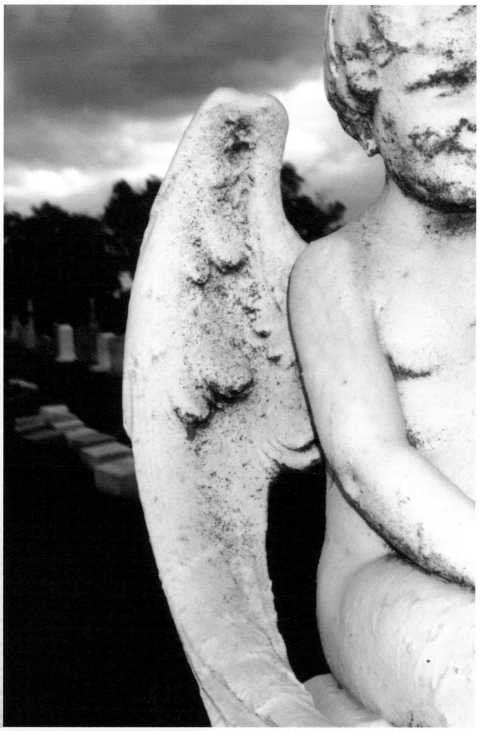

Credentials

I would were it possible to state in so
few words my errand in the world: quite simply
forestalling all inquiry, the oak offers his leaves
largehandedly. And in winter his integral magnificent order
decrees, says solemnly who he is
in the great thrusting limbs that are all finally
one: a return, a permanent riverandsea.

So the rose is its own credential, a certain
unattainable effortless form: wearing its heart
visibly, it gives us heart too: bud, fulness and fall.

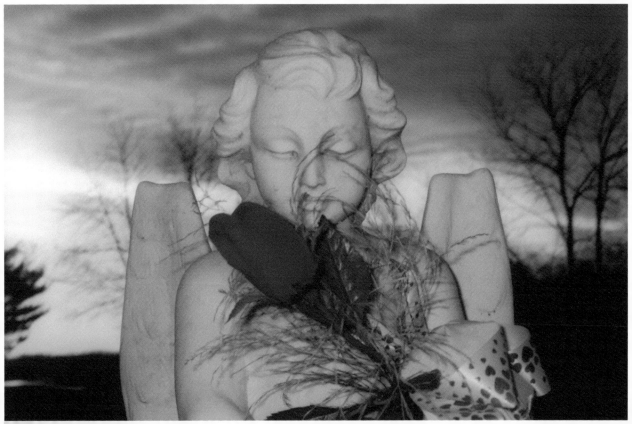

Flowers

A flower is single jeopardy—
only one death; matrons' scissors, dogs'
natural deflowering; choose! Meantime
dare time and wind and war. Be

no one's metronome, discount
in a lover's hand, the ways
we die—routine, wrong analogy.

I start these words because
a girl on a bicycle
swaying

bears a few flowers
homeward through war, a double jeopardy.
I held
breath for her, her flowers, on the wheel of fire,
the world, no other.

Sentries, we passed, no countersign

except *good-bye*
forced first last word of all.

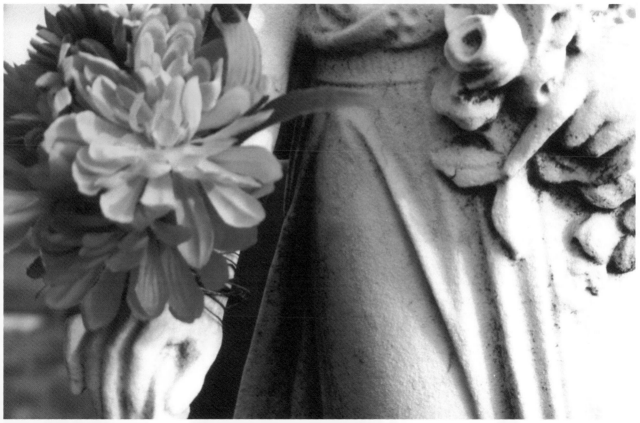

Strength

issues in marvels:

crucial delicate finger at flute stop.

Hill easing itself like tiger's body, around one
blind tuft of violets.

A spring after, felled oak, one
heartbeat unspent: one
handful of leaves
 in a dead hand.

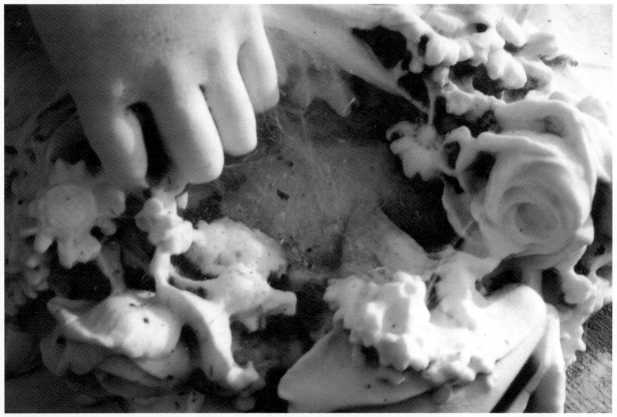

Child Above a Flower

 unsure
if he regards
or is regarded.
 Both is a truth
older will fade.
Come, said flower
race me to evening.
 Time is a way
no one knows.
 Who
goes there?
 who went there
answer our tears, sighs

flower's ghost. Growth is a death
on my youth laid.

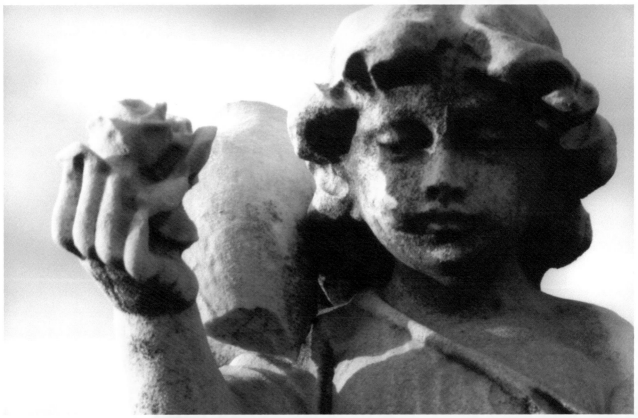

Play Safe; His Friends
(The Gospel According to Me)

Of course death was hard, hard for the poor.
Yet one finally took it in stride,
closing a father's eyes, seeing the mild slumbering
seas turn monstrous.

 But this:

 God, unutterable,
friend, mildly poured
over days and years. What words were left us
(this hard exchange, this other side of death?)

Whether we turned locks in a remote alley
or pushed off into seas and stars: the dawn
rose to him, evening breathed him
 It was always
never again to be safe, summed up our lives.

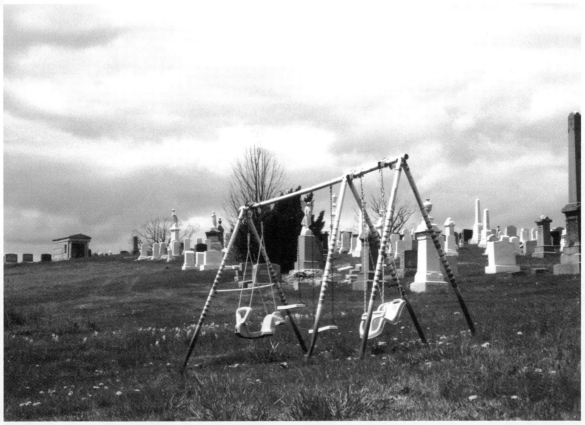

Help Me Someone

I should like to know please
the name of that girl
lauded in some obscure corner
of the press

dead in Paris
buried in Père Lachaise cemetery,
dedicated it was said, to the common good

an American girl
solicitous
succoring
showing the city of light
an unaccustomed
incandescence.

Where then?
her bones make
so small a sound
in the noiseless sockets
of history

and *learn! learn!* is the law
whereby we stand
and they
cut free.

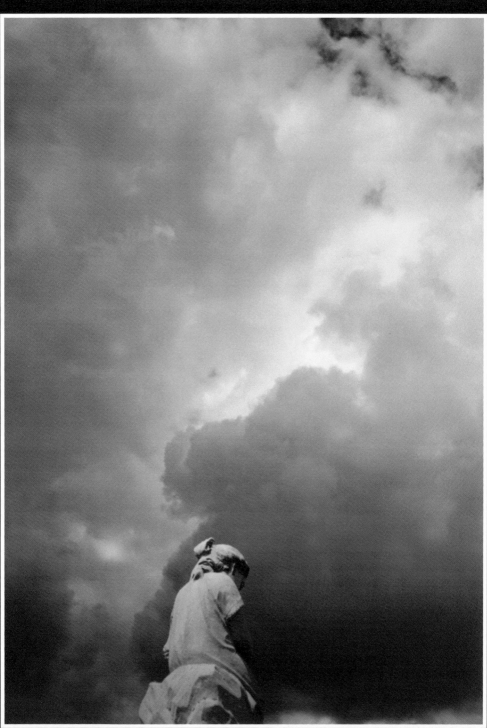

If

If I am not built up
bone upon bone
of the long reach and stride of love—

if not of that
as stars are of their night;
as speech, of birth and death; thought
a subtle paternity, of mind's eye—

if not, nothing.
A ghost costs nothing.
Casts nothing, either; no net,
no fish or failure, no tears like bells

summoning across seas
the long reach and stride of love
dawning, drowning those black waters.

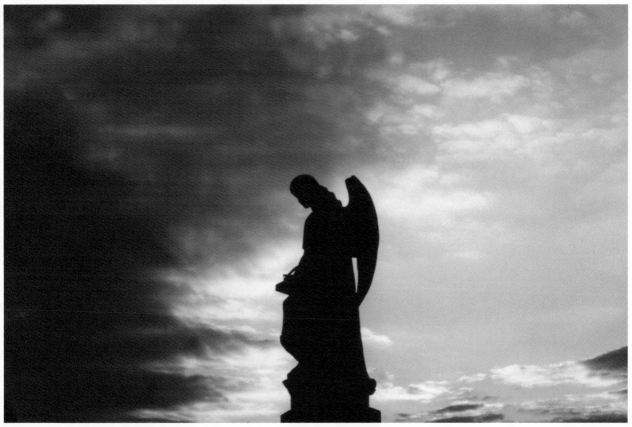

Awakening

When I grew appalled by love
and stood, a sick man
on feeble knees
peering at walls and weather
the strange outdoors, the house of strangers—
there, there was a beginning.

The world peeled away
usual upon usual
like foil in a fire.
Fell that day, all summer
That day, mind made an elegy
world might gape and weep.

I forget it now.
But remember too; a green tree
all winter's ignorant winds trampled in vain.

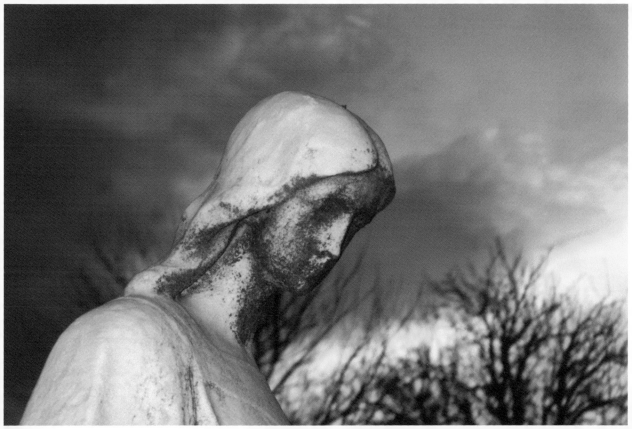

In Sum, Like This
(The Gospel According to Me)

Who you are
let astounded midnight say
that saw itself flooded with day

or springtime that came around
subtly on the world's wheel
and saw you, small and larger, walking its ground

or suave on a boy's tongue
the air making your words
and taking them grandly, a whole summer of birds:

let that mother tell
whose earth and heaven were small
between hearthside and village well

or the dumb tree that bears
pegged down, posted as ours
forever, the unsearchable human years.

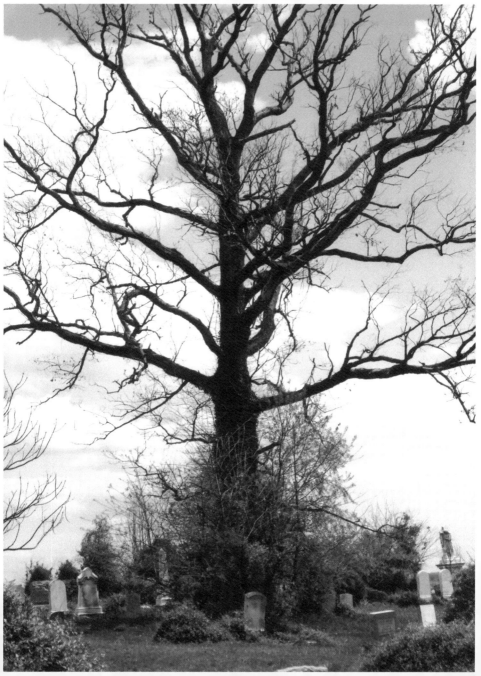

Little Hours (II)

Winter is hard: it reminds us how that mother,
heavy and meek at term, set foot on her dolorous road.
Her trees, ample and tender at summer
were slit and groaning beggars the wind went through:
the sun that clothed and companied her angel:
what fierce looks from him, and scant comfort now!

Mother: because the ungracious season did not rise
—at your footfall, for knowledge of whom you carried,—
leap cliffs with roses, melt the tigerlike ice
into tame brooks for you—

 because north wind blew
and summer hid—enter stilly my heart
whose winter your footfall breaks all apart.

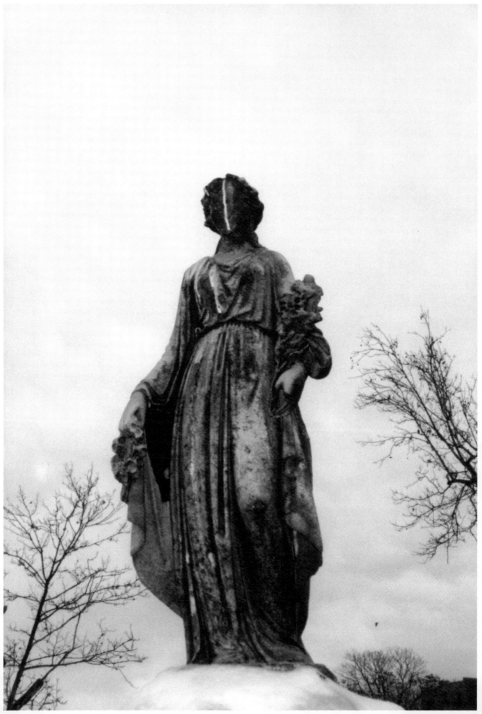

I Encounter Men in the World

hopelessness stands in their eyes,
dry despair, hands broken upon stones,
eroded lives

I think then, of a young mother
her child in arms
a concentrated inwardness
as of a sea shell coiled, its music
self-composed, self-given.

I long at sight of illness to induce
—as a shell drawn from seas
generative, uncorrupted—
some birth their tears had not dared come upon.

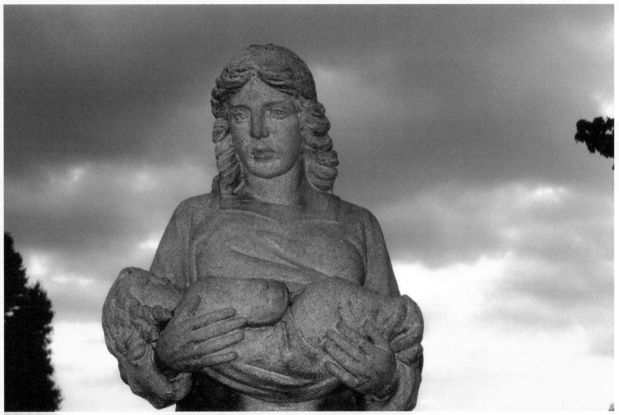

Miracles

Were I God almighty, I would ordain,
rain fall lightly where old men trod,
no death in childbirth, neither infant nor mother,
ditches firm fenced against the errant blind,
aircraft come to ground like any feather.

No mischance, malice, knives.
Tears dried. Would resolve all
flaw and blockage of mind
that makes us mad, sets lives awry.

So I pray, under
the sign of the world's murder, the ruined son;
why are you silent?
feverish as lions
hear us in the world,
caged, devoid of hope.

Still, some redress and healing.
The hand of an old woman
turns gospel page;
it flares up gently, the sudden tears of Christ.

Christ

Words are outer form
wherein majesty might near,
 if it so please:
of limb and mien not substance,
but light; glancing,
 announcing: lo, he cometh.

Words summon her too,
 the mother unfolding
like a kerchief, odor and form
 of him who lay there:
so in repose her body grew
a spiritual space to round
 and radiate you:

friends, whose memory
call up your ghost at cockcrow:
 there and not there
if tears glister or no:

so, struck from you holy flesh,
 distance and
access, our words begin
 like lepers' bells: O come
not near.

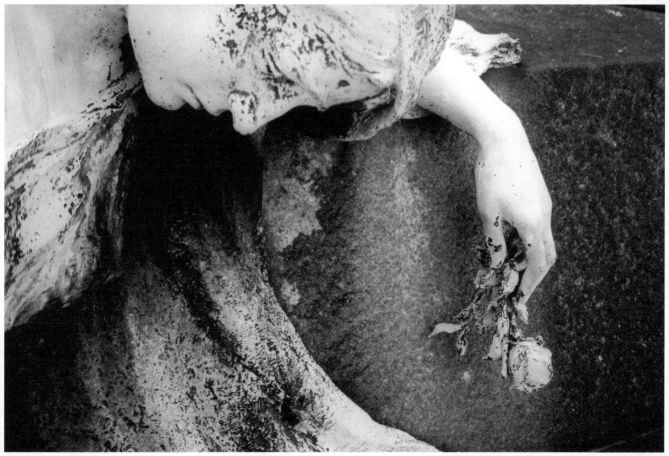

Pope Paul Goes to Jerusalem;
the Mona Lisa and the Pietà Go To New York

If geography's the tip of someone's
scholastic needle, we'll ripen and rot there.
But life? Mona Lisa tries her luck
in treacherous waters. The innocuous stare

warms, her body cleaves the waters
like time's ripe swan. And Pieta, too long
in stale unanswering air; *whose sorrow*
like mine? Lady, we've not lived as long

in churches, but we die too, in droves.
In Queens meadow raise your eyes
from classic grief. The dead
bury the dead, and deep. Come walk our streets. Like Paul

the sun almost destroyed, that white moth.
He sweated under the cross, the raving
combustible crowd, a hanging or crowning mood.
In dreams, the living eat his flesh, his blood runs
nightlong a staved cask in those alleys.

My dream beats on. I see the dead
in naked majesty, consumed with longing
for what we in the common street have by heart;
the leaf's errant fall, a child's cry. Delicate,
 brutal; impure, pure-the world, the world—
 breaks them apart.

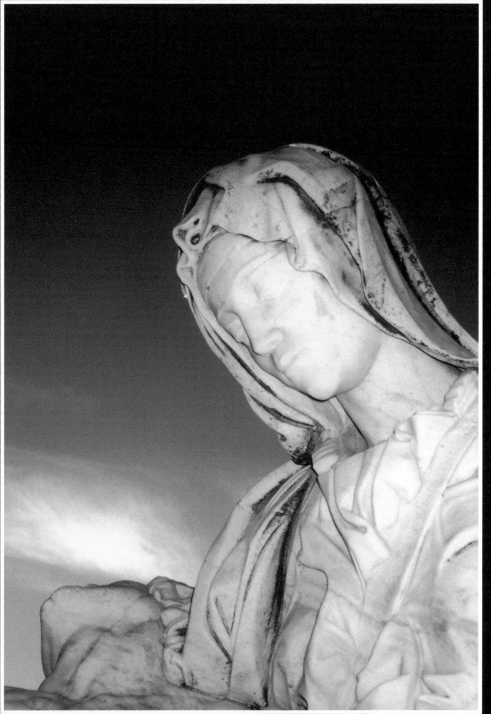

He Paused

and spoke: *coopers, craftsmen, shepherds*
blessed is the prophet
whose blood speaks in his stead. Search death out

and sought death in their cities, and was taken
young years and all, composed in ground
like wintering bees

and after respite stood again
in tremendous mime, (shut doors sprung,
permeable world)
all we would come to.

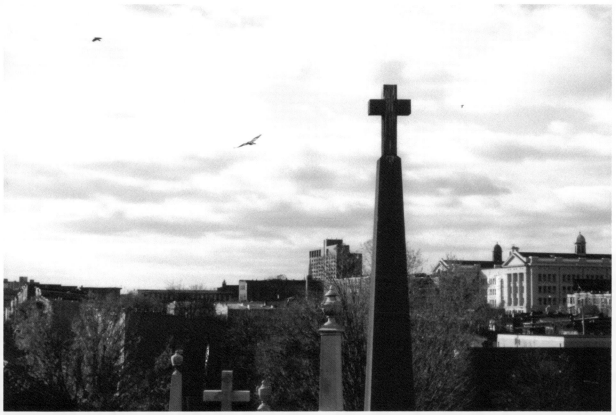

Death Casts No Light on the Mind

It is not for that; not
permeable at all, an Easter cross.

He crossed himself, and climbed

Then then
imagination springs; it tastes
mulberries, risen tigers, Himalayas,
summer lightning—

He leaped eternity
(whisper goes),
 a tiger to its prey.

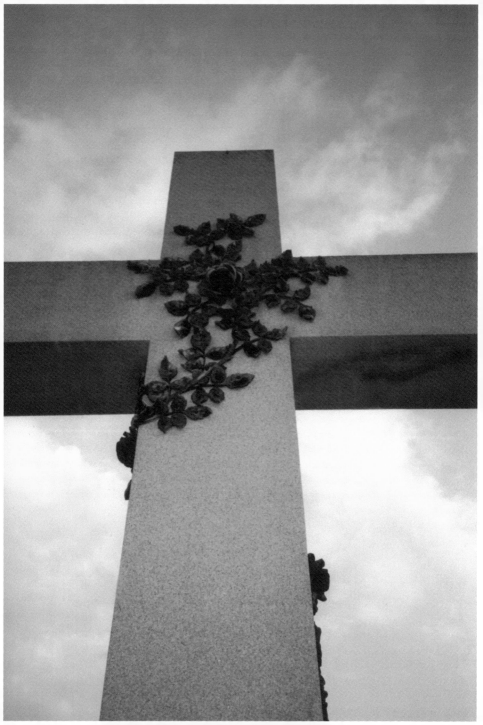

And He Fed Them All

That throng
Christ had worked wonders for—

The gentle blind
hearing like fauns
the fall of leaf, the hunters mindless will—

the halt
like marvelous broken statuary;

they come for eucharist, as though rumor ran
in grim autumnal streets
long cold, long unfed

of miraculous loaves and fishes among the dead.

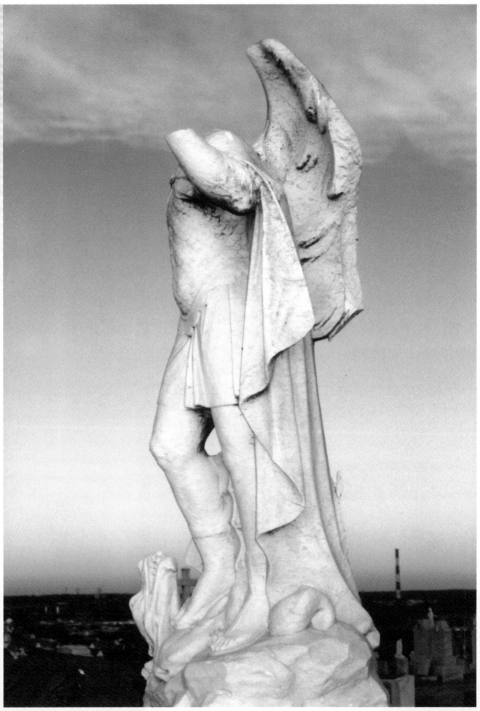

The Entrance

> We came to a portal
> Stern unbending an angel acosted
> > *What errand brings the living*
> *out of due time among the dead?*
> > His short sword clove the air
> > stopped us in our tracks
> I knelt seven times his blade traced
> a serpentine S on my forehead
> Blood tears fell on my face
> > *Welcome* *to dolor*
> > *to glory*

> We entered The gates clapped to
> like the two hands of God
> > ordaining ends and beginnings.

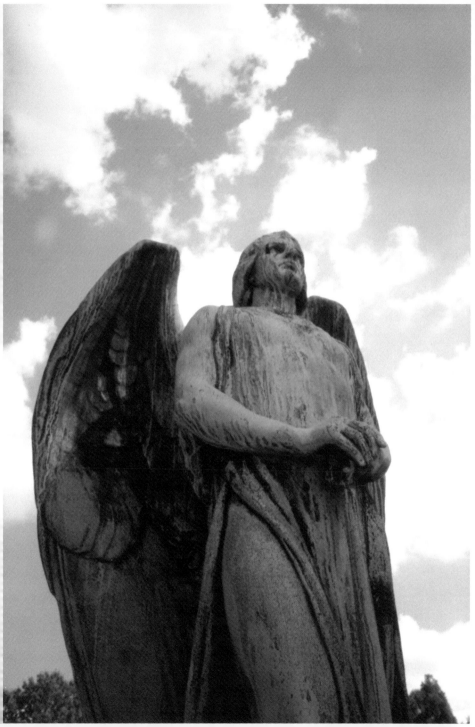

The Angel of Humility

An angel approached
arms open in greeting then
 he touched barely touched
my forehead *The way* *be easier now.*
 Indeed the way eased
 or was it rather
lightening
of soul's gross baggage?

 Like one who all unheeding
bears on his person some mark or brand
 and reads only in others'
 amusement or dread
how awry he walks—
 I put hand to my forehead—
 That welt and wound
 assuaged part healed!

 A choir of souls
 struck up my soul's
 breakthrough—
Blessed the poor in spirit!

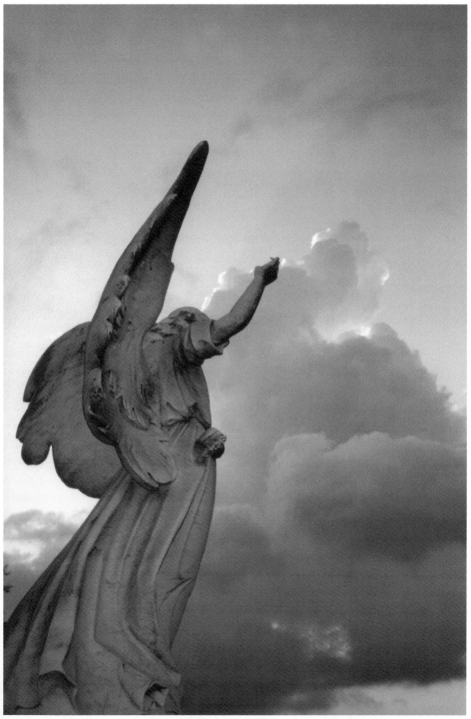

Obit

We die

showing like frayed pockets, space within
without, for loss.
 Pain in eyes, a ragged
animal before the gun;
 muzzily—
can death do any harm
life hasn't done? maybe
(dreamily) *death*
turns old dogs
into fish hillsides butterflies
teaches a new
trick or two

Beyond

What lies beyond—
Beyond scope and skill,
beyond
wayward winds, capricious minds,
beyond, beyond despair—

lies within, plenary and pure—
compassion's clear eyed child.

What lies beyond,
beyond
dole and bribe and
browbeating eyes,
beyond mandated terror—
lies, within;
 I mean
solace, end time
sweetly present
in sad or gladsome hours—
creator Spirit, hand in mine,
a ringaround, pure light.

What lies beyond,
(diaphanous, denied,
beyond
 the death of promise)—
lies within.

Hear it;
the golden tongued
choral ode of the unborn.

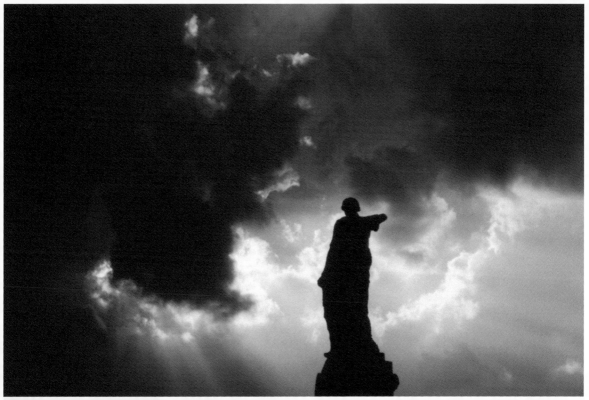

Lazarus

Sister, you placed my heart in its stone room
where no flowers curiously come, and sun's voice
rebuffed, hangs on the stones dumb. What I could not bear
I still must hear. Why do your tears fall?

why does their falling move Him, the friend, the
unsuspected lightning: that He walk our garden
with no flowers upon His friend?

what did He say in tears (grief
scalding my hands, cold hands springing
sleep like a manacle) drawing my eyes a space
that had seen God, back to His human face?

Lazarus I

Silence rolled over, over my body its
monstrous milling; a fine dust
settled on millstone death.

If truth were told, the white dust could not tell it
even when that young Magian
cried *open-sesame* and puffed me to a man.

Lazarus II

After my world was only
two women above me, and they murmuring
gradual farewell, like bells or heartbeat—

I could not care, nor summon
to whisper *I do not care*. Yet for them
heart stood like a stricken drummer: one beat more.

It was not death! Though his steps slower fell than the great stone,
he cried; *I am the way*

and banished death away
chiding
from the stone doorway
away
their tears.

Etty Hillesum
(d. Auschwitz, Nov. 30, 1943)

"Here goes then," wrote this woman I never heard of.
And "I don't want to be safe, I want to be there."
Wrote this woman.

She is like a God I never heard of.
She is like a bride I never married.
She is like a child I never conceived.
Like death? Death she heard of

death she walked toward, a child lost
in the glowering camps.
After years and years—recognition!

I heard a cry; "My child!"

The ineffaceable likeness. Death
her child, her semblable.
Wrote "In such a world I must kneel. Kneel down.
But before no human." In the furnace
lust and its cleansing, birth and its outcome.
To kneel where the fire burns me, bears me.
Eros, God, Auschwitz.

 She wrote; "To live fully
outwardly, inwardly, my desire. But to renounce
reality for reality's sake, inner for outer life—
quite a mistake."

Wrote to her lover; "Dear spoiled man
now I shall put on my splendid dressing gown
and read the bible with you."

O singer of songs of songs, O magnificat Mary
O woman at the well of life!

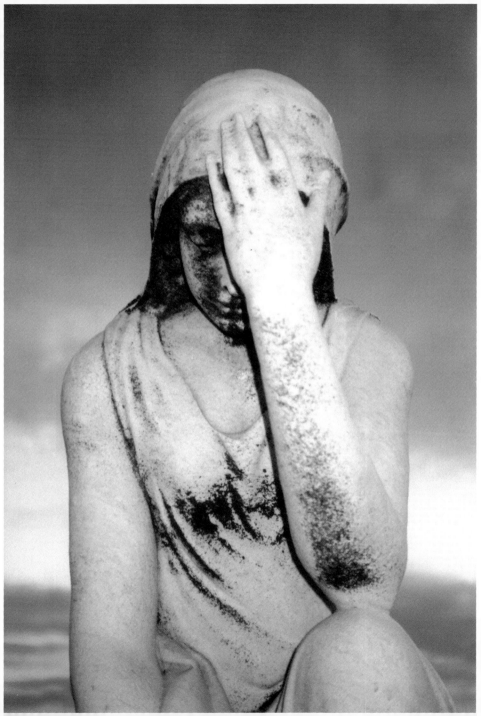

Mimi

We kept watch with Mimi dying.
Miles away, soul
kept tugging back.
You've seen
a daredevil falling,
 then landing safe,
 ease, ease the parachute home.

That's not soul. Soul is wind
against silk, racing counter.
Nor a kite—soul's not a kite,
soul is wind; that
animate thing, dipping, prancing,
is merest clue.

The holy bread touched lip
pale as shot silk. We kept watch, intoning
'Body of Christ.' Then; wind,
a bird, a bird like wind
quicker than ravens in parables of wind—

What goes counter? where?
(we cried) and why
always elsewhere?

We saw nothing, and we knew.

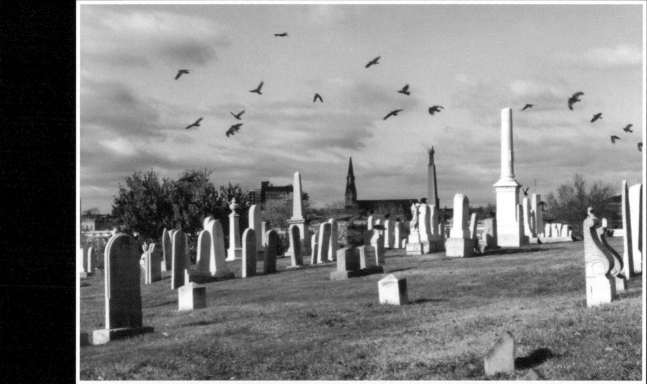

David Joyce
(a young peacemaker dies on Good Friday)

A most unamerican life!
no money
no lies
no fear—
soul
like the single note
of a spring-wet willow whistle.
It sounded.
Summoned, he walked.
And of long drawn
wailing at the wall,
nothing.

Finally, A Song of Songs

We shall see your face again
and the lost pearls
will grace your forehead, grace
the breast of the bride.
The beloved shall touch you
to ice and fire.
You shall know her
and be known.
And both shall sow and both
together reap.

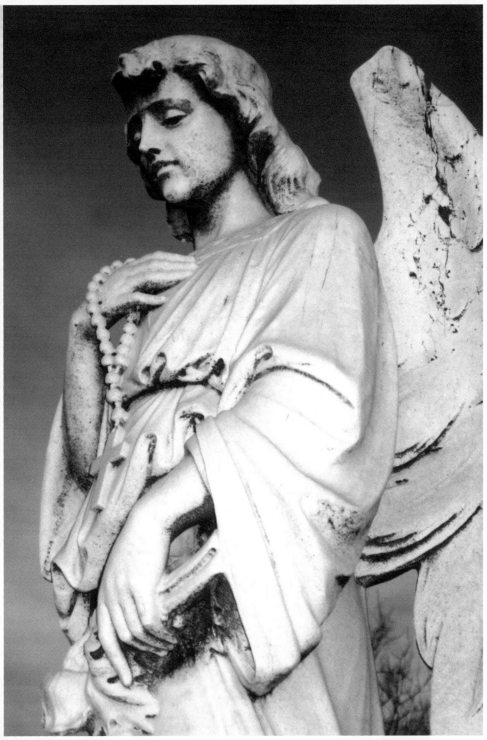

You Finish It: I Can't

The world is somewhere visibly round,
perfectly lighted, firm, free in space,

but why we die like kings or
sick animals, why tears stand
in living faces, why one forgets

the color of the eyes of the dead—

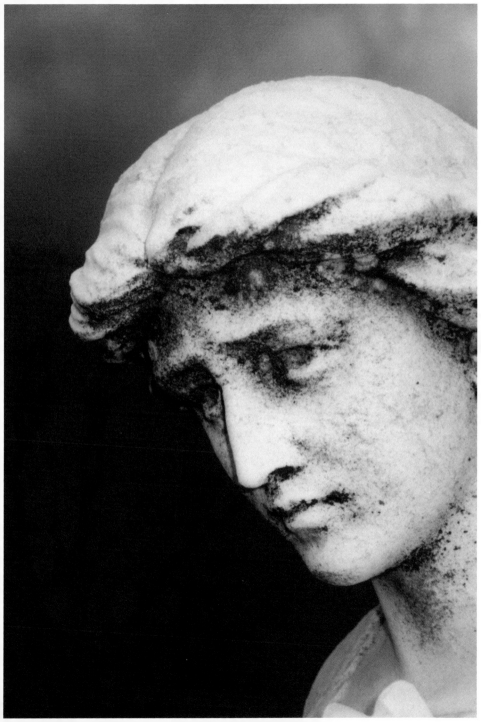

Sorrow

I saw a mother
mourning her sick child
the hundredth time that day
or any day or night
equally wearying, equally hopeless.
She sees death stand at the end of days.

And saw a young husband;
his wife, suddenly dead, borne to the church door,
he, serving at Mass
impassive, cold at wrist and heart
to match her cold, one ice laid on one flesh.

The exemplary world moves us to tears
that in their falling, purify
eye's glance, impure world, both.

I know the world now, if world has face.
It beats steadily as a child's heart.
It is the moon's rhythm
that like a woman's long
unutterable glance of love
draws the bridegroom after.

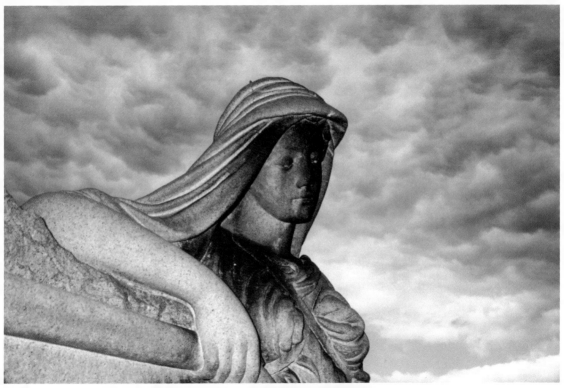

Landscapes There Are

of formal will and silken atmosphere;
where is the legendary Chinese brush
drawing us
 gently into stillness?

Not conquest of height
nor grandiose will
but an uncopyable phrase

a bough in one direction
running.
 Like a child's legend or a death
or *I love you*, never in history repeating itself.

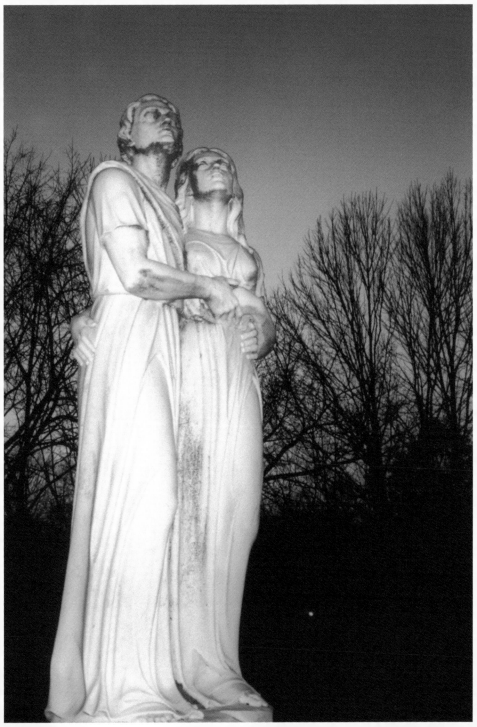

Go Down on Knee

I saw an old wife stricken, the man
bending painfully above: *let me serve, be
eyes, limbs.*

 Man, wife, wearing for better for
worse, the other's flesh, rent and patch: *I do*.
Bridal gown is yellow as bone, raveled

like youth out many a gay and slower
mile: stained bowler and waistcoat, a
rusty charmer.
 Yet all days since, I see
visible things of this world, faultless
and heartening, go down on knee before, fashion
music toward, measure hope and
decline upon
 the least audible heartbeat
of this holy darkness: *I love you.*

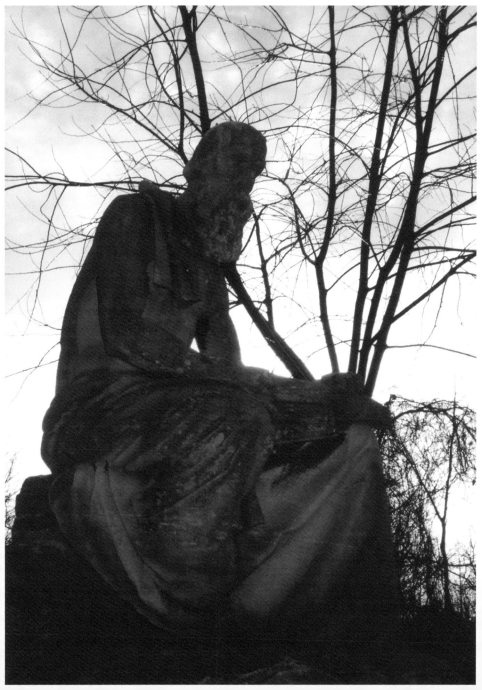

An Old Woman In Death

For words words;
 death's instantaneous
waterfall
granted all at once
what sun fumbles weeks upon,
 and only debatedly
brings to pass: I say spring

that springs her absent eyes:
like flowers whose seed dies in
temperate air, they fade here: but in height
elsewhere, are majestic blue

blue wept her eyes when she cried aloud:
in fear or exaltation, no one knows.
The woman who died
shook a worn garment aside

bride somewhere again
 by loving
 makes beautiful.

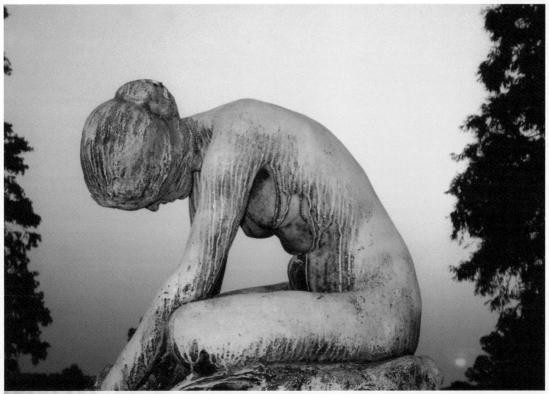

We Love

about trees: past is never tall enough,
future too tall. Another spring will tell.

Tell another spring
 I will be there, and fairer.
I become myself
that throat of swan
that striding giant I decree myself.

We love: in trees, in us, how may die
forward on the blade.
 I see men like forests
striding, like swans riding, always
royally: though lowly afoot, striding into death.

What we love: there are not blades enough

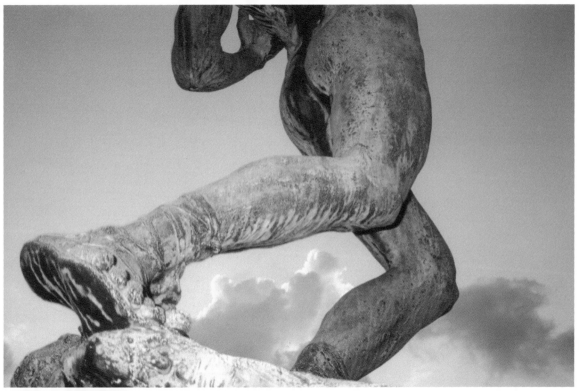

Compassion

I sing bronze statuary
enduring rain and cold,
alert eyes casting back
the sun's burning shafts
a fisher's net soaring,
snare
to catch worlds in.

But in November rain
 —rotting asters, scum of leaf—
came on a dying man.

His eyes pled
like an animal at the block
Come to this? And I
kneel upon squalid ground
 defeat striking
marrow and heart;
Unless I suffer this, you
gentlest Abel, strike
with a glance, Cain down.

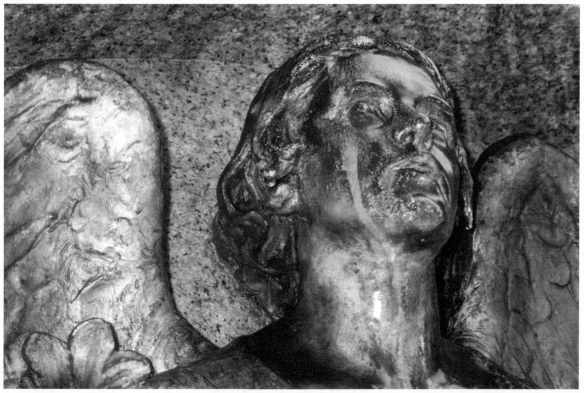

The Wound

I have endured more
in the plight of those I love
than ever in my flesh.

The plight is consequence.
The cause is steadfastness.

I tremble for their fate.
The rub is raw.
 Relief?

 We die, the mortal
wound is one, another.

Salvation History

I had a nightmare—
the rickety shack brought down
I was sheltering in;
from sleep to death
gone, all coped in dream

What then? I had never lived?
it well might be.

Without friends, what am I?
their noon and moon, my own
Without friends—what?
dead, unborn, my light
quenched, never struck.

The piteous alternatives
life simulates!
streets haunt, faces hang

but I mark
like an unquenched man
merciful interventions

a clean end or beginning
someone to die for some love to sing

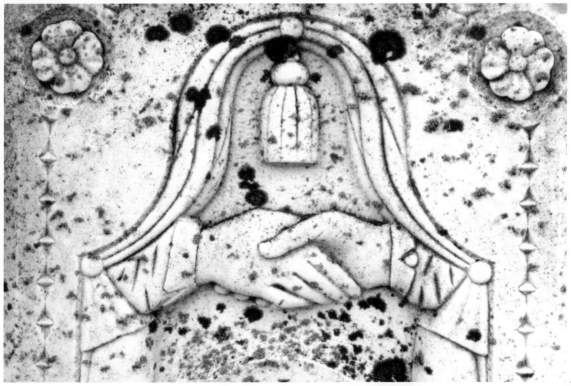

False Gods, Real Men (To Philip)

Compassionate, casual as a good face
(a good heart goes without saying)
someone seen in the street; or
infinitely rare, once, twice in a lifetime

that conjunction we call brother or friend.
Biology, mythology cast up clues.
We grew together, stars made men
by cold design; instructed

sternly (no variance, not by a hair's
breadth) in course and recourse. In the heavens
in our mother's body, by moon and month
were whole men made.
We obeyed then, and were born.

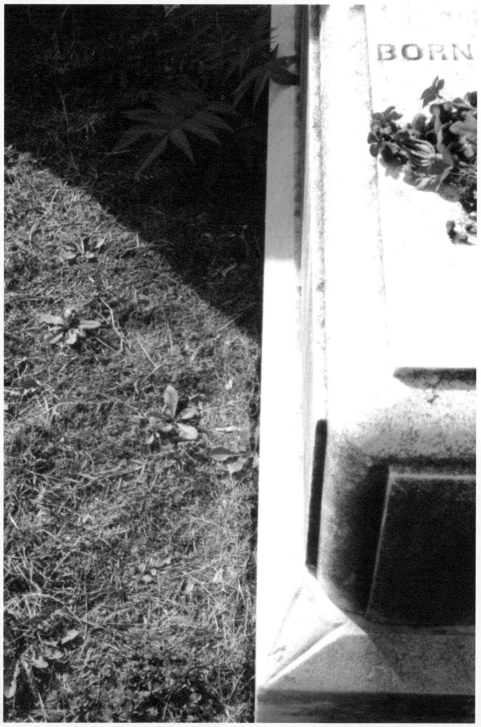

Events

Events are orthodoxy, he would say,
submitting like any son.
The way a fruit tastes of itself
he tasted sacrifice.
No thirst but for that cup
engendering thirst.

Credo is event, would say
to a brother's face
by birth or death brought near—
a descending god he saw, a god
sprung from his tears.
Piety of experience
bound him in web.
He wore the world for wedding band.

Here
A few notes toward a life.
Words, words, we buried.

Look; time wears new feature; time takes heart.

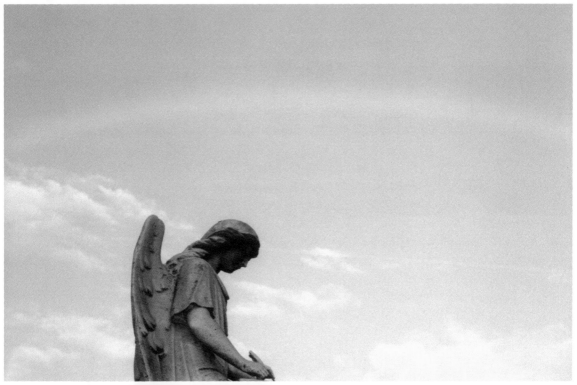

To Philip

Dimidium animae meae; the half
of my soul, Augustine wrote.

Death keep you intact, dear brother.
Death's finger cross your lips –
not a word, a syllable, a sigh
escape.
 I mourn,
I accede, the absolute
dictum; chafed bones,
skull put to silence, the slow
diurnal surrender of flesh to earth.

'Don't be', your law of being
elsewhere. Your 'Now', a not to be –
absolute, unbribeable by tears.

Faith, a huge boulder, rolls
athwart the cave
named (alas for lack) –
twilight, memory.

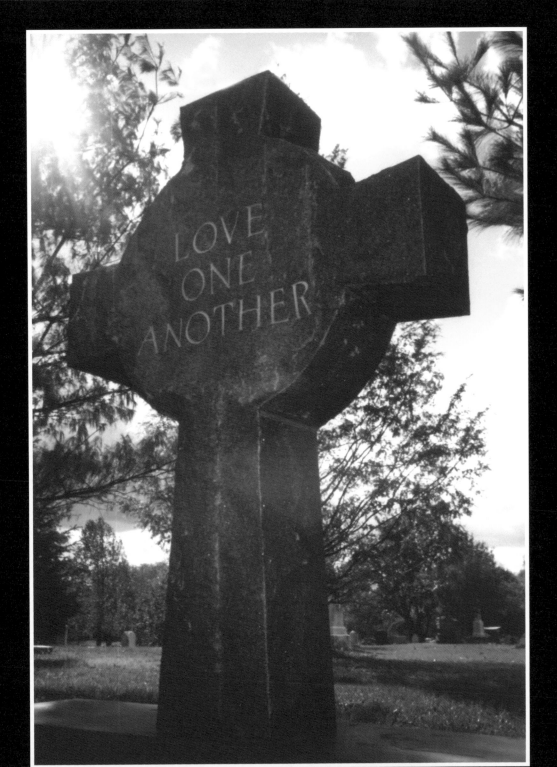

My Name

If I were Pablo Neruda
or William Blake
I could bear, and be eloquent

an American name in the world
where men perish
in our two murderous hands

Alas Berrigan
you must open those hands
and see, stigmatized in their palms,
the broken faces
you yearn toward

you cannot offer
being powerless as a woman
under the rain of fire—
life, the cover of your body.

Only the innocent die.
Take up, take up
the bloody map of the century.
The long trek homeward begins
into the land of unknowing.

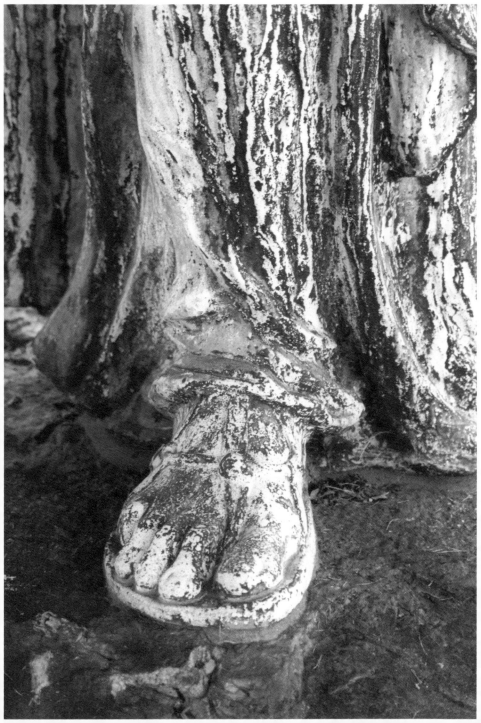

Facing It

Who could declare your death,
obedient as Stylites, empty as death's head
majestic as the world's sun moving
into night?

It was a hollow death; we
dread it like a plague. Thieves die this way,
charlatans, rejects. A good man's thought recoils;

to grow old yes,
home and faces
drifting out of mind. Abrupt violence yes
a quick mercy on disease

but not, not this; the mother's face
knotted, mottled with horror,

time's cruel harrowing
furies at the reins of fortune
wild horses dragging
the heroic dishonored body on time's ground.

O for an act of God! we cry, before death utterly
reduce to dust
 that countenance, that grace and beauty.

But
come wild hope, to dead end. War, murder,
anguish, fratricide.

No recourse. The case of Jesus Christ
is closed. Make what you will

desire, regret, he lies
stigmatized, a broken God
the world had sport of.

Risen? we have not turned that page.

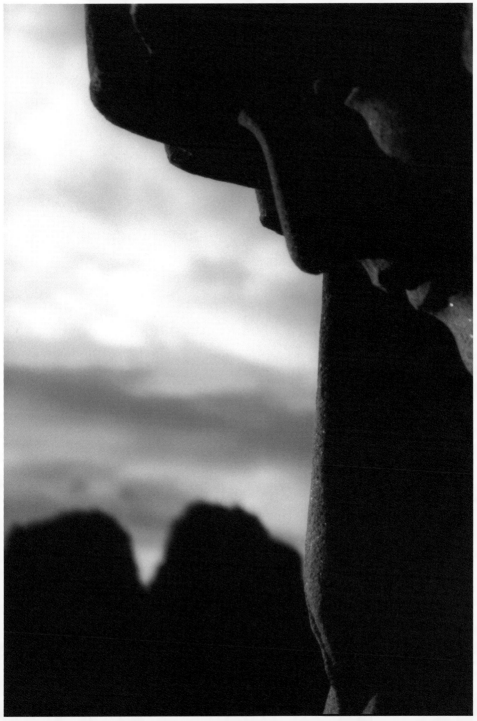

Cardinal

I mull about
in the grab bag of the mind
(fits, starts, vague scraps,
intentions raveled, faded)—
then
forgiveness.
Let us forgive one another.
Better, let us pray;
O cloud
of murdered witnesses, forgive
our furtive or bold trespass
on sacred ground,
out hatreds diffused, denied
in soulless sacred jargon.

Cardinal, let us kneel,
ask pardon of murdered children
of Vietnam, of Salvador.

The children bathe us
with cupped hands, our tears
lo! innocent as theirs.

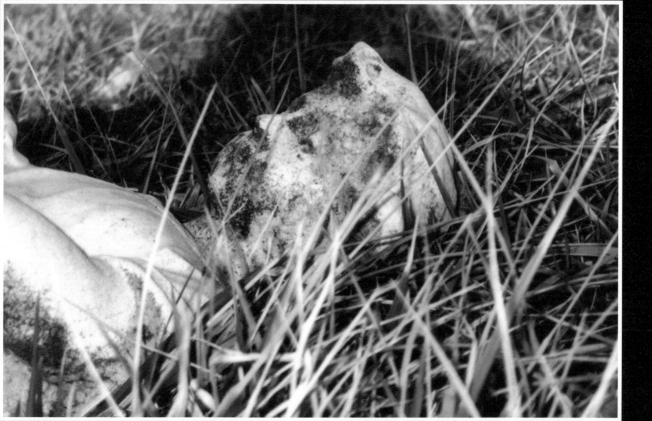

The Sermon on the Mount, and the War That Will Not End Forever

Jesus came down from Crough Patrick
crazy with cold, starry with vision.
The sun undid what the moon did; unlocked him.

Light headed ecstasy; *love*
he commended, as tongue and teeth
fixed on it; *love* for meat after fast;

then *poverty*, &
mild and clean hearts stood commended.

Next spring, mounted Crough Patrick
and perished.
The word came down
comes down and down, comes what he said
men say, gainsay, say nay.

Not easy for those who man
the mountain, forever ringed and fired.
And the children, the children
 die
die like our last chance
 day
 after Christian day

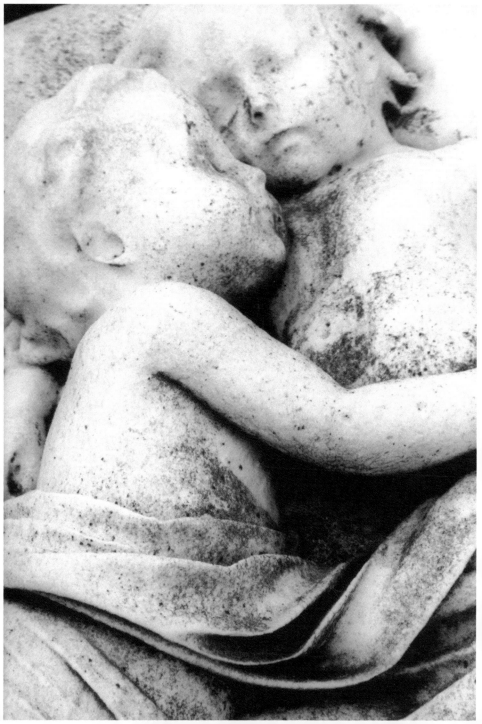

Prayer for the Morning Headlines

MERCIFULLY GRANT PEACE IN OUR DAYS. THROUGH YOUR HELP MAY WE BE FREED FROM PRESENT DISTRESS … HAVE MERCY ON WOMEN AND CHILDREN HOMELESS IN FOUL WEATHER, RANTING LIKE BEES AMONG GUTTED BARNS AND STILES. HAVE MERCY ON THOSE (LIKE US) CLINGING ONE TO ANOTHER UNDER FIRE, TERROR ON TERROR, GRAPES THE GRAPE SHOT STRIKES. HAVE MERCY ON THE DEAD, BEFOULED, TRODDEN LIKE SNOW IN HEDGES AND THICK-ETS. HAVE MERCY, DEAD MAN, WHOSE GRANDIOSE GENTLE HOPE DIED ON THE WING, WHOSE BODY STOOD LIKE A TREE BETWEEN STRIKE AND FALL, STOOD LIKE A CRIPPLE ON HIS WOODEN CRUTCH. WE CRY: <u>HALT</u>! WE CRY: <u>PASSWORD</u>! DISHONORED HEART, REMEM-BER AND REMIND, THE OPEN SESAME: FROM THERE TO HERE, FROM INNOCENCE TO US: <u>HIROSHIMA</u> <u>DRESDEN</u> <u>GUERNICA</u> <u>SELMA</u> <u>SHARPEVILLE</u> <u>COVENTRY</u> <u>DACHAU</u> <u>AFGHANISTAN</u> <u>IRAQ</u>. INTO OUR HISTORY, PASS! SEED HOPE. FLOWER PEACE.

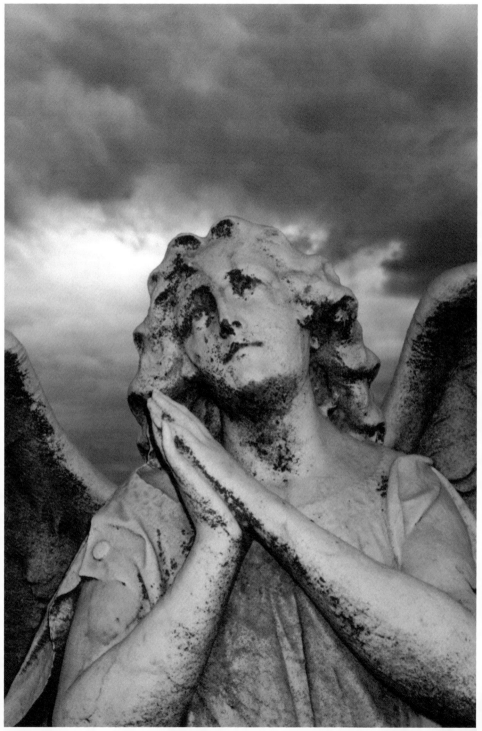

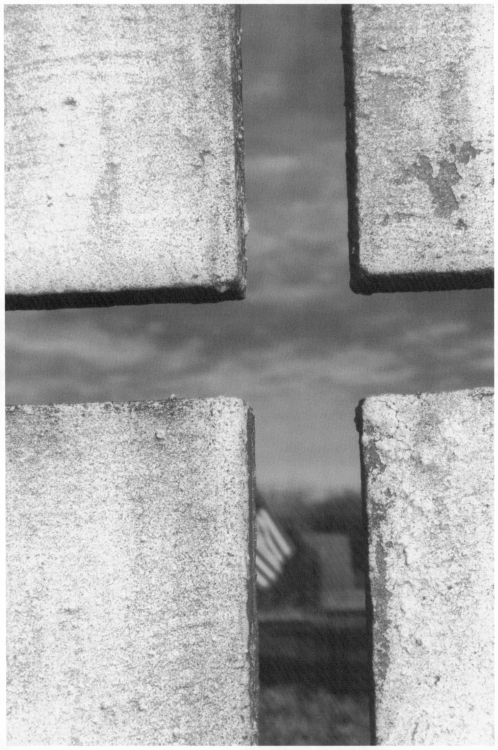

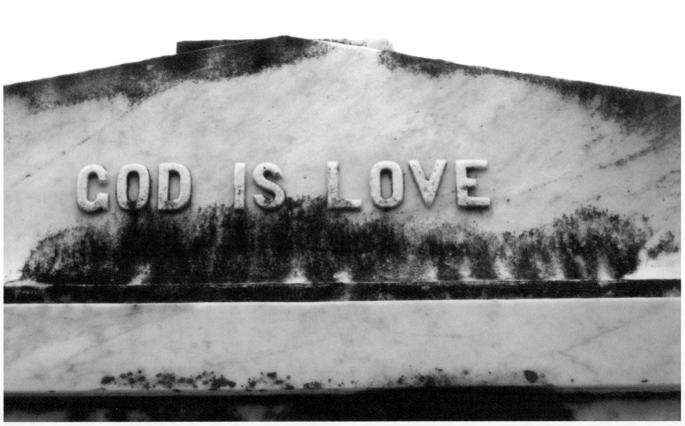

Afterword

By Adrianna Amari

In the early 1990s, after traveling throughout the states and abroad—grassroots organizing in New Orleans, playing piano in Australia, recording gamelan in Indonesia—I settled in Baltimore. One night a visiting friend and I got lost while driving through unfamiliar neighborhoods and came upon a gothic structure surrounded by angels looming on a hill, lit by the moon. We set out to find this vision again in daylight, and spent magical hours in a place called Green Mount Cemetery, a serene landscaped place in the heart of the city.

From that day on I photographed Baltimore's cemeteries, driven to capture what I sensed in these surprising sanctuaries of silence, curve, and light amidst urban chaos. The power of these anonymous bronze and stone testaments to ongoing love—of fathers, mothers, sisters, brothers, sons, daughters, friends—moved me time and time again. Over the years, while working in a children's hospital and pursuing my doctorate, I amassed thousands of images of this sacred world of figures standing on the threshold between death and life.

In 2002, following a brain hemorrhage, I became blind in my dominant eye and found it difficult to take more photographs. Fortunate to be alive, and convinced that this juncture was guided by providence, I began to collect the images together for what was to be a meditation on life and death. I selected my favorite photographs, but over the next months various ideas about accompanying texts came and went.

In the spring of 2004, I planned a trip to Block Island off the Atlantic coast of Rhode Island. I previously lived and worked there, and my dear friend with whom I had discovered the cemetery angels still lived there. We were going to participate in a vigil against the war that would take place during my visit. She called me excitedly a few days before my visit to tell me that Daniel Berrigan would be there at the same time. Father Berrigan frequented the island through the years. In fact, F.B.I. agents posing as birdwatchers captured him there in the summer of 1969 while he was underground after the infamous Trial of the Catonsville Nine. A year earlier, during the height of the Vietnam War, Berrigan and eight others, including his brother, Philip, publicly destroyed draft records with home-made napalm in front of a selective-service center in Catonsville, Maryland.

I gathered up my Berrigan poetry books to bring with me to Block Island. I loved Berrigan's poetry, and had been inspired by his devotion to peace and justice, since my adolescence. As a young woman I had written the Jesuit priest to tell him of his influence on me, and of my vague dream of co-authoring books on peace. His living example, along with those of others from the past

who had devoted their lives to reverence for life—
Gandhi, King, Schweitzer—led to my participation
in demonstrations, marches, and actions devoted
to social justice, and to my eventual profession in
service to those with pain and illness.

These many years later, I stood in silent
vigil against the war in Iraq alongside Father
Berrigan and a handful of Block Islanders. There
the clear dream came of combining my statuary
photographs with his poetry to make a larger
statement about sanctity and mourning and
peace. With encouragement from my friend and
my husband, I stayed on the island until I was
able to speak personally with Father Berrigan at
some length. We sat and talked about poetry and
Brecht, our work caring for those with medical
conditions, and of Baltimore and his brother,
Philip, whom I had joined with other members of
Jonah House in a march on Washington shortly
before his death. Father Berrigan looked at the
collection of photographs I had brought, and
I mustered the courage to ask him about the
project. He responded, kindly and simply, that I
was free to use any poems that he had written if
I felt they could be appropriate in theme. I had
already started dog-earing pages in his books, but
was amazed during the several weeks that followed
to find striking connections between my images
and specific poems, as if I had unknowingly been
taking pictures for his poems all along.

What resulted is this book, which sadly and
ironically, neither my beloved friend nor husband
lived to see come to fruition, though both believed
it would. It is a book that I hope will provide
some beauty, compassion, and contemplation
of the profound meaning of each and every life
and death, especially in these times. May Daniel
Berrigan's life-long efforts for peace, and his
poignant and powerful words, contained in part
herein, be known and heard for all generations.
It is an honor for me to be associated with him,
and with Howard Zinn, an inspired and inspiring
writer and activist. Along with their example and
words, may these images from my adoptive city of
Baltimore also bear witness and contribute to the
illimitable hope for peace all over the world.

Acknowledgments

I am so grateful for my editor, Gregg Wilhelm, for his willingness and efforts to make this a tangible book to hold, and for the advisory staff and students at Apprentice House.

My most humble gratitude goes to Father Berrigan for his words, inspiration, and generous collaboration. Deep gratitude also to Howard Zinn, for his eloquent introduction, and to the late Kurt Vonnegut, Ramsey Clark, James Carroll, Martin Sheen, Amy Goodman, Stephen Duncombe, Rafael Alvarez, and John Dear for their contributions.

My respect to the memory and families of the departed, and my appreciation to those who tend the cemeteries in Baltimore where the photographs were taken (exceptions: pages 17 and 104 were taken in New Jersey, 21 and 87 in Canada, and 105 in New Orleans).

Thanks to those who directly and indirectly helped me with this project: Andrew Kaslow, David Beaudoin, Rafael Alvarez, Peter Kanaras, Lisa Starr (Hygeia House), Peter Voskamp (Block Island Times), Andy Shallal (Busboys and Poets), Elizabeth McAlister, Deirdre Hammer, Stacy Winnick, David Goodfriend, Glenn Moomau, the late Grace Love, Constance Scott, Cheryl Knight, Kathryn Winterle, Paige Dobry, Keith Slifer, Dosia Paclawsky, Michael & Marilyn Cataldo, Leo Howard Lubow, Jim Burger, Ilya Finkelshteyn, John McDonald, Sandra Mudge, Valerie Sklarevsky, Greg Ruggiero, Denis Moynihan, Susan Gould (Baltimore Gallery), LuAnne Cara (Zoe's Garden), Simon Price (Simon's), Annette McGuire (Strictly B'More), Megan Hamilton (Creative Alliance), Crystal Dunn (Severn Graphics), and the people of Block Island (especially at St. Andrews) and at Jonah House, Red Emma's, Techlab, Artography, Kinkos (Charles Village), and Flash Mail (Guilford Avenue).

My appreciation goes to the teachers who gave and who were themselves examples of those who dedicated their lives to peace, social justice, poetry, and beauty —particular thanks go to Kenneth Tubertini, Harry Furman, John Forrest, Richard Cameron-Wolfe, and all the spiritual guides of all faiths, traditional and non, over the years.

I have endless gratitude to my neurosurgeon, Dr. Rafael Tamargo, and to Drs. Bagley and Rothman, for saving my life and thus making anything I do possible.

Very special thanks go out to my wonderful family —my mother and her love of books, father and his love of living things, brother Frank (my special advisor) and companion Lois, and niece Christina for unconditional love and support.

In loving memoriam of my husband, Jeffrey Sarli (1958-2006), who provided me with dear and soulful companionship, and my dear friend, Emily Reeve (1940-2005), who magically guided so much of this journey.

Biographies

Block Island Times

Daniel Berrigan, S.J., is a Jesuit priest, poet, author, teacher, and peace activist. Author of over fifty books, he is the recipient of the Lamont Poetry Award for his poetry and Tony award for his play "Trial of the Catonsville Nine." He has been nominated for the Nobel Peace Prize many times for his life-long peace efforts, participating in numerous acts of protest and civil disobedience such as those with the Catonsville Nine and Plowshares Eight.

Jim Burger

Adrianna Amari is a classical pianist, poet, peacenik, and photographer. With undergraduate training in cultural anthropology, she traveled extensively abroad before moving to Baltimore where she completed a doctorate in psychology. She holds a position at the Kennedy Krieger Institute and is a member of the faculty of the Johns Hopkins University School of Medicine.

Howard Zinn is Professor Emeritus of Political Science at Boston University. He is a historian, playwright, social activist, and author of *A Power Governments Cannot Suppress*, as well as the bestselling *A People's History of the United States*.

The future of publishing...today!

Apprentice House is the country's only campus-based, student-staffed book publishing company. Directed by professors and industry professionals, it is a nonprofit activity of the Communication Department at Loyola College in Maryland.

Using state-of-the-art technology and an experiential learning model of education, Apprentice House publishes books in untraditional ways. This dual responsibility as publishers and educators creates an unprecedented collaborative environment among faculty and students, while teaching tomorrow's editors, designers, and marketers.

Outside of class, progress on book projects is carried forth by the AH Book Publishing Club, a co-curricular campus organization supported by Loyola College's Office of Student Activities.

Student Project Team for *Prayer for the Morning Headlines*
 Kayleigh Clark, '09
 Regina Lyons, '07
 Amanda Merson, '10
 Margo Weiner, '07

Eclectic and provocative, Apprentice House titles intend to entertain as well as spark dialogue on a variety of topics.

Contributions are welcomed to sustain the non-profit press's work and are tax deductible to the fullest extent allowed by the IRS.

To learn more about Apprentice House books or to obtain submission guidelines, please visit www.ApprenticeHouse.com (made possible by the generous support and creativity of Mission Media). To order Apprentice House books, call 410-617-5265 or fax 410-617-5040.

Printed in the United States
111788LV00003B